Zen Brush
Tao Words

From Imperfect Design to Ultimate Realization

From Struggle to Perfection

Gene Lavon Porter, MA

Order this book online at www.trafford.com
or email orders@trafford.com

Most Trafford titles are also available at major online book retailers.

Author Credits: The Nature of Form in Process: A Principia Forma

Printed in the United States of America.

ISBN: 978-1-4269-6209-7 (sc)
ISBN: 978-1-4269-6210-3 (e)

Library of Congress Control Number: 2011904421

Trafford rev. 03/28/2011

 www.trafford.com

North America & International
toll-free: 1 888 232 4444 (USA & Canada)
phone: 250 383 6864 ♦ fax: 812 355 4082

This book is dedicated to all the architects and architecture students of the world, especially to Bailey Porter and Ram.

Might you all save that world with your creations.

CONTENTS

Preface: From struggle to perfection

Artwork: Zen brush and Tao words

(The following pages are not numbered. Each page is considered a work of art unto its own. Numbers are assigned here and are identified on each page by the Tao words on that page.)

PREFACE: From struggle to perfection

Leonardo Da Vince struggled with 'knowledge through vision' at an early age. He perfected his method through his experiments, his art and his notebooks.

Miyamoto Musashi was Japan's greatest swordsman. Through great struggle, he perfected a form of strategy and won every match. Later, he wrote "The Book of Five Rings" which became the bible of Japanese business strategy.

As a boy, Thomas Alva Edison struggled with the "Amateur Scientist" experiments in "Scientific American" magazine. Later, his inventions flowed from him like electricity flows along a wire.

In his first issues, Hugh Heffner struggled with his "Playboy" magazine layout. Hee! Hee!

Walt Disney struggled with the complex movie "Fantasia" with its many facets and later invented the interdisciplinary Disneyland concept where bits and pieces formed a whole new world.

Frank Lloyd Wright struggled with the use of a simple pencil and ruler. He later became the greatest architect of his day with these basic tools of the profession.

You get the idea.

I struggled with the complexities of two, interdisciplinary Master's degrees. Some time later, I found the simplicity of Zen in the Sumi-e brush and ink style. I then learned to condense the Taoist poems of the Tao Teh Ching, a Chinese religious text of almost eighty poems. It was after this struggle that my ideas began to flow – simply and naturally. And so we have it. Great struggle leads to perfection. The flow of creativity eventually happens naturally. In my artwork, "No need to take the lead," number 40 in this book, each bird was made with one stroke of the brush: beak, eye, head and neck. I knew how to do it without thinking because I had struggled with similar problems many times before.

I end this preface with the following:

> And on my grave,
> Place these words:
>
> *He tried!*

Gene Lavon Porter, M.A.
Porter Creative Arts
Laughlin, Nevada, February 2011

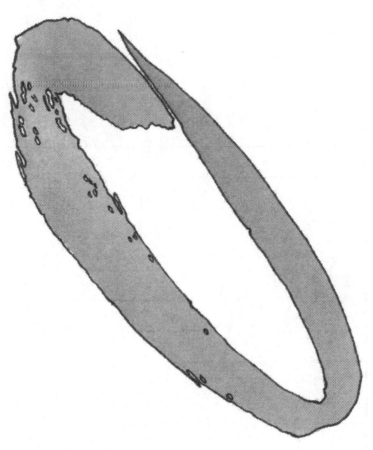

Without beginning
Without extent
Without end

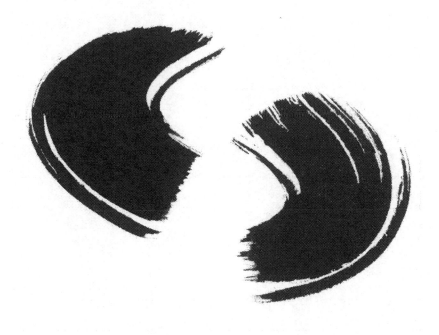

Like a vast hollow well

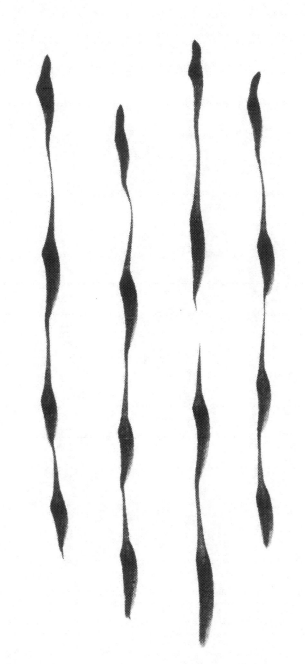

It is great without display

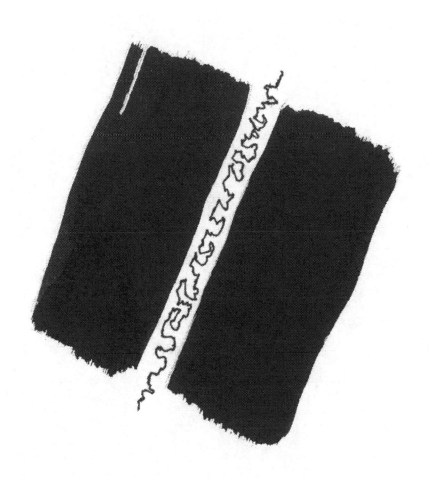

Its supply is endless

In its receptivity
does it continue

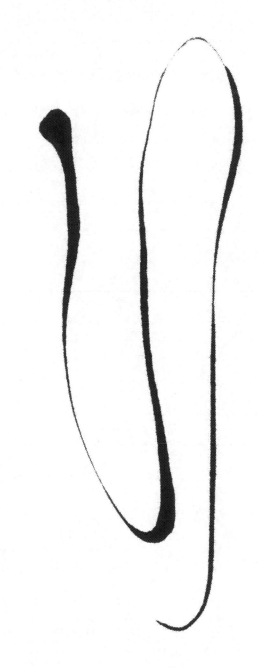

Some things stand
naturally in the
foreground

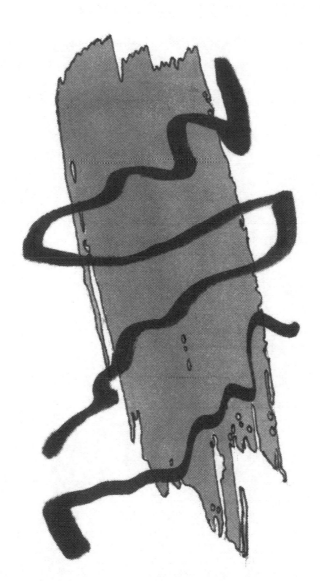

and others in
the background

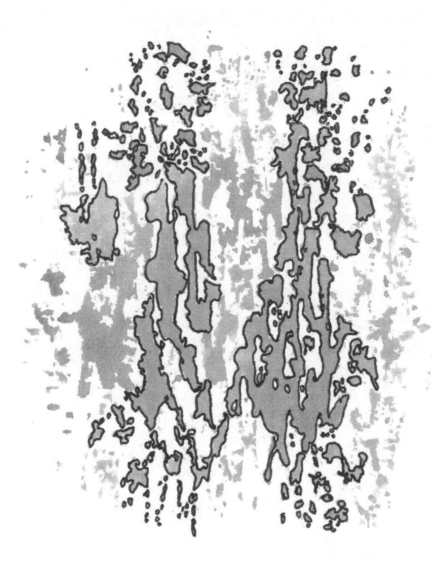

Merge into one

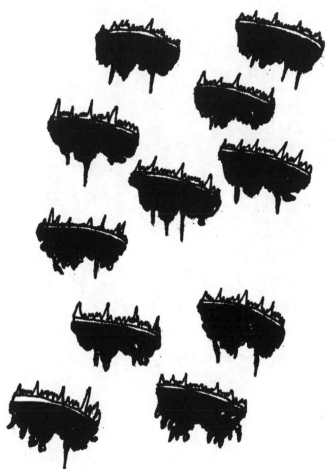

Latent energies
which arise

Have never ceased

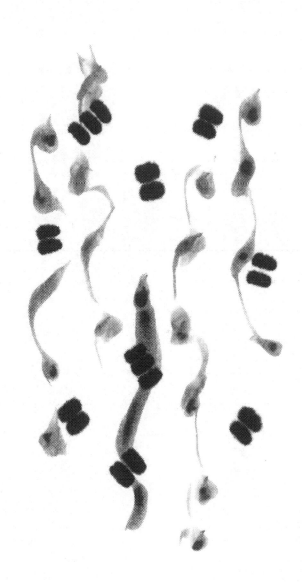

Into the
depths of
a deeper
mystery

Gives life without
possession

Accomplishes without
credit

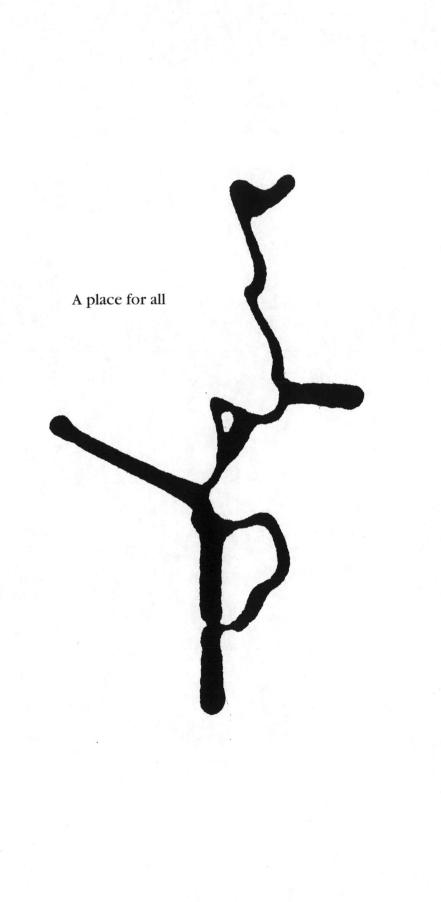

A place for all

Confidence
and
fulfillment

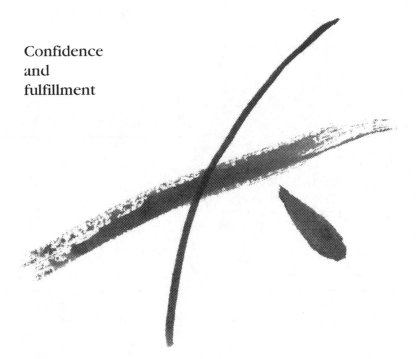

are increased

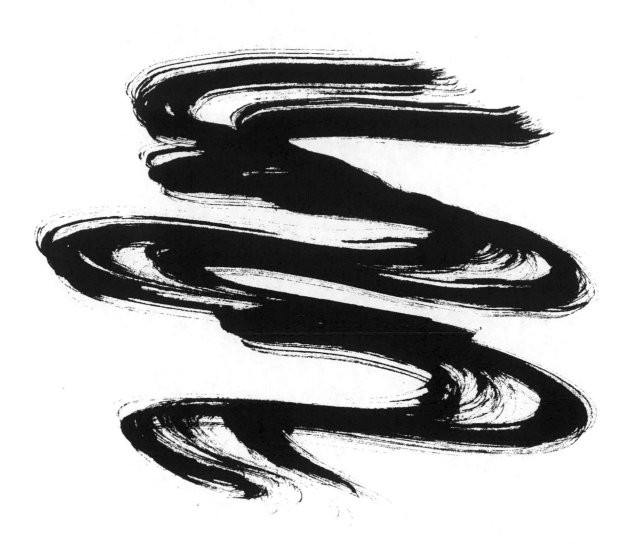

It becomes a lake bed
to the stream

Work is done

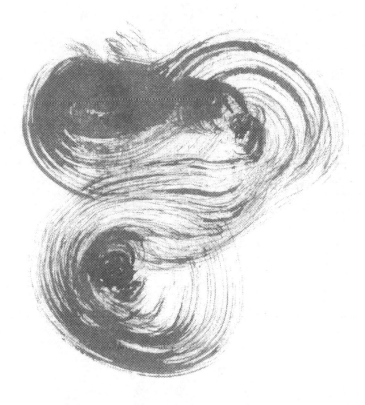

with quiet efficiency

Allow
the
natural
flow

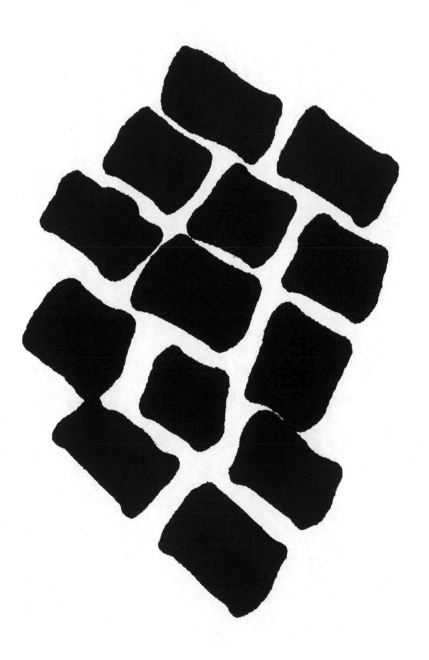

Remain supple
and open
in the light

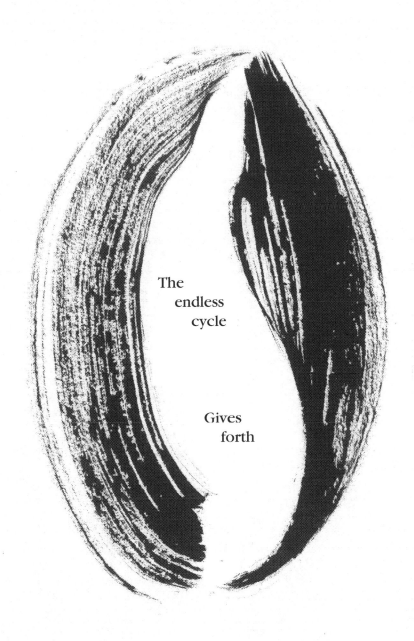

The
endless
cycle

Gives
forth

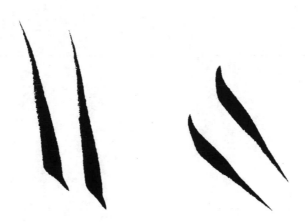

Be satisfied

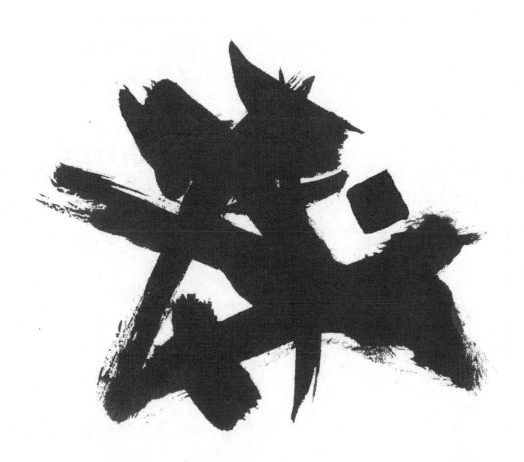

Be receptive

The
integrity
of
the
whole
is
insured

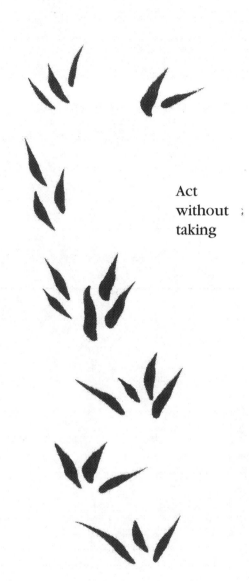

Act
without taking

The
small
parts
are
not
less
than
the
whole

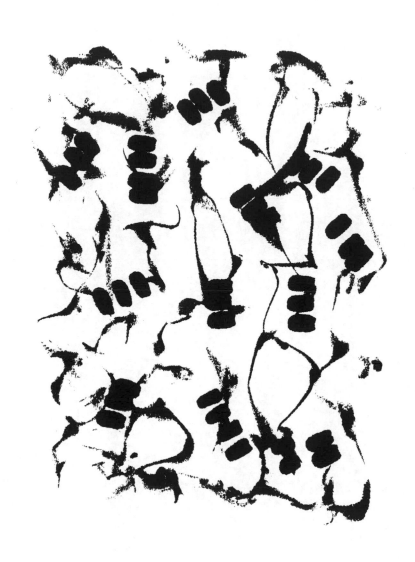

Only different

There
is
service

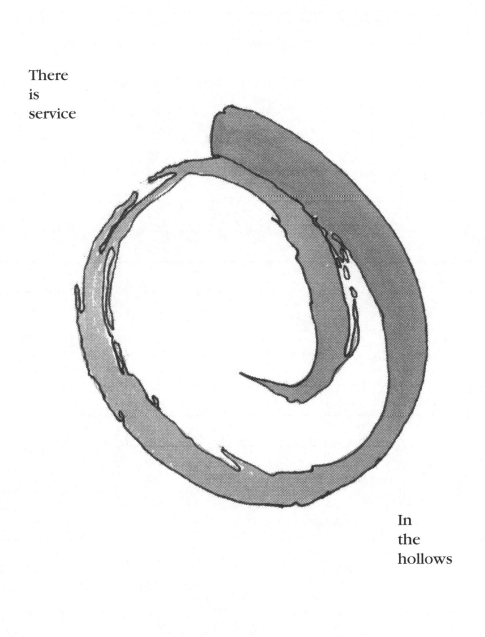

In
the
hollows

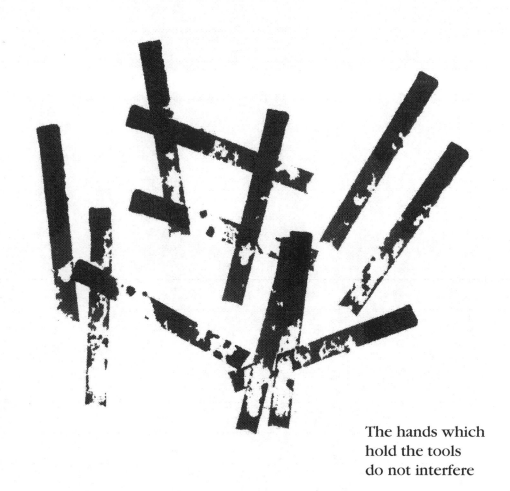

The hands which
hold the tools
do not interfere

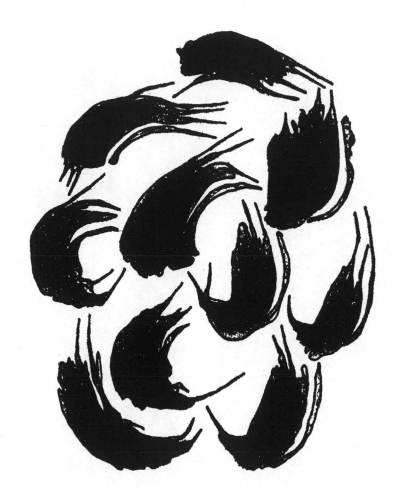

Not
by
stimulation
alone

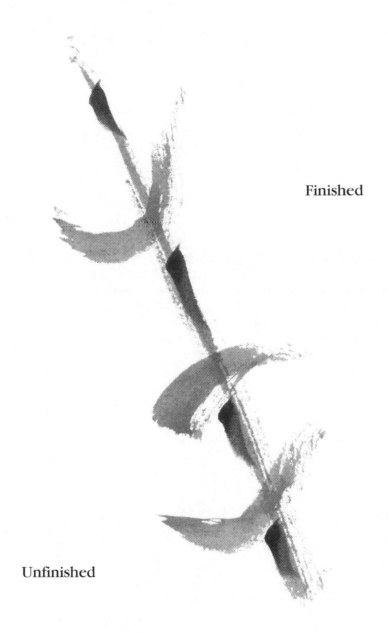

Finished

Unfinished

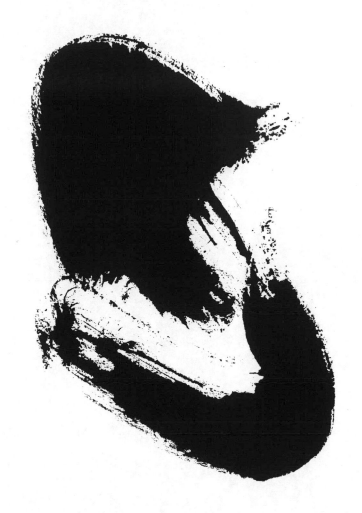

While the mud settles

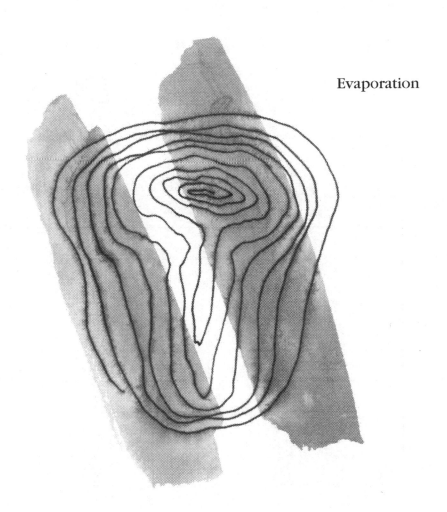

Evaporation

and
rainfall

With
trust

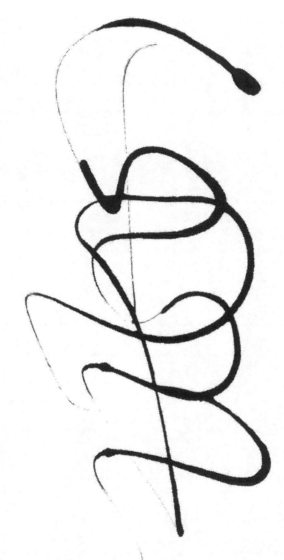

With
ease

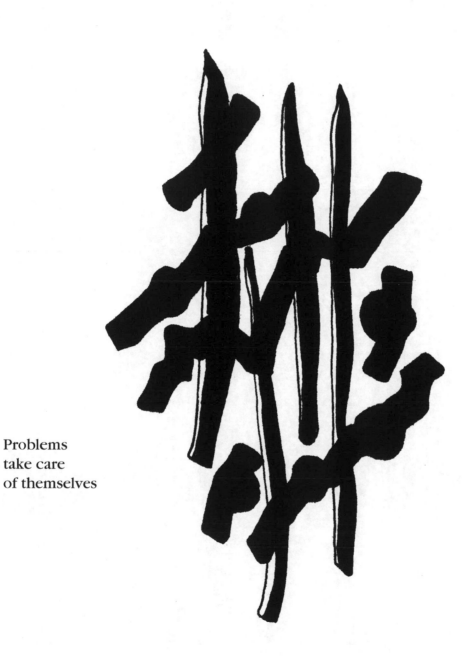

Problems
take care
of themselves

The
whole
is
allowed
to
come
of
its
own

Falls
like
soft
rain

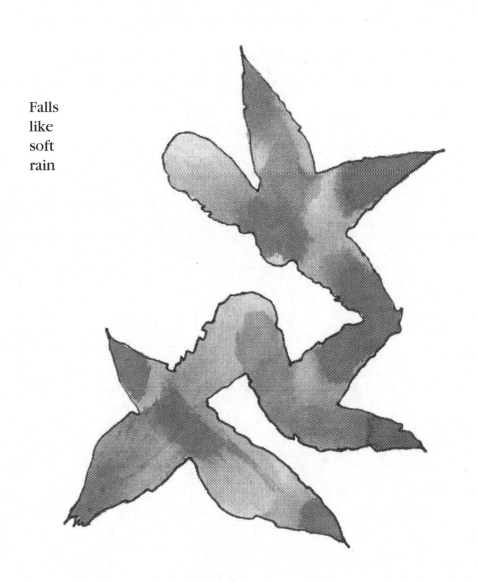

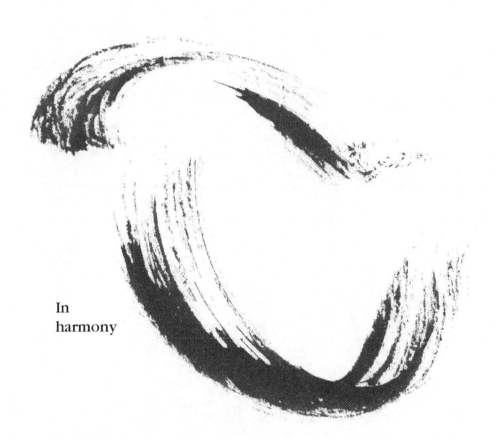

In
harmony

Devotion

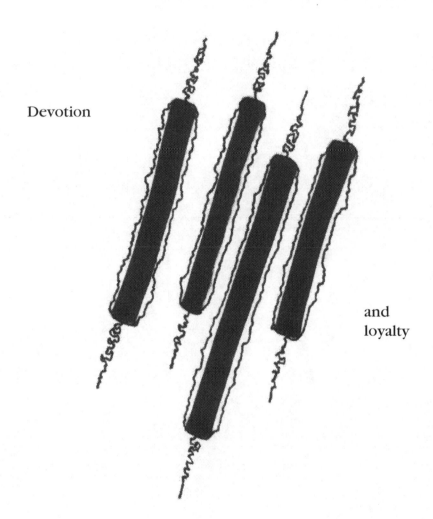

and
loyalty

Reveal
the
simplicity

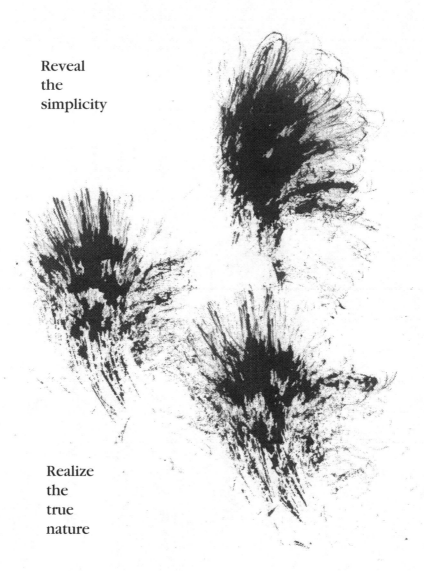

Realize
the
true
nature

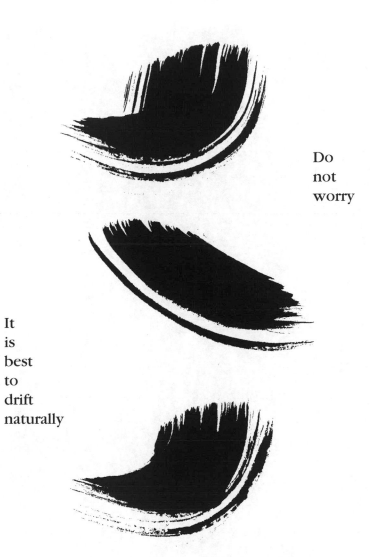

Do
not
worry

It
is
best
to
drift
naturally

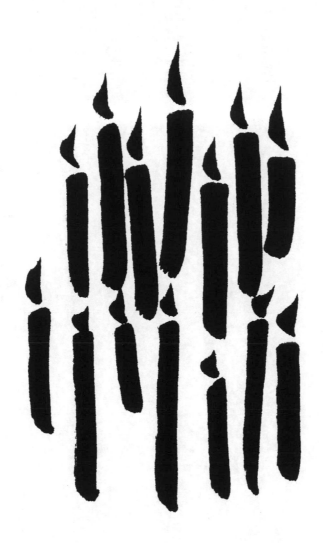

A quiet place
to come together

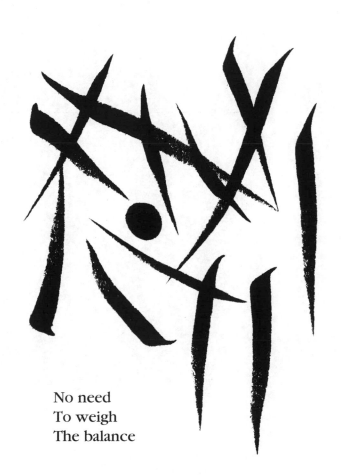

No need
To weigh
The balance

Return
again

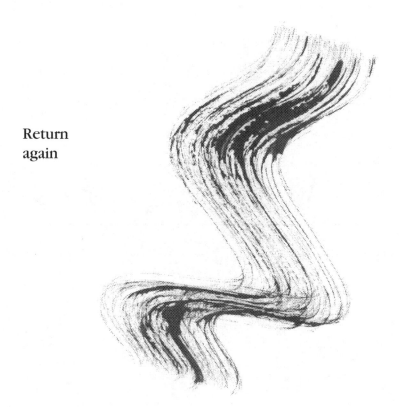

To the
quiet
pool

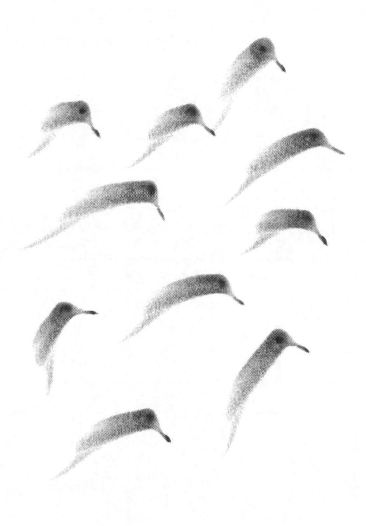

No need
 to take the lead

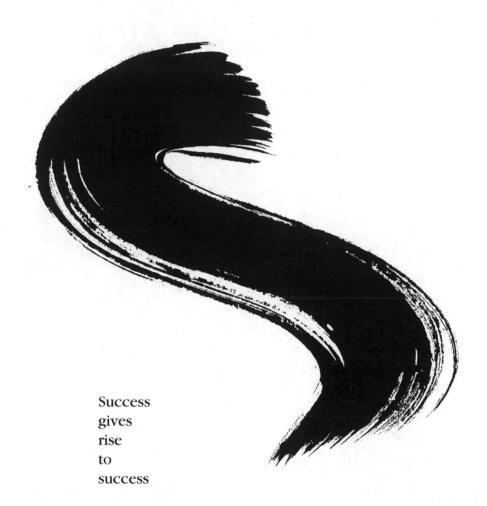

Success
gives
rise
to
success

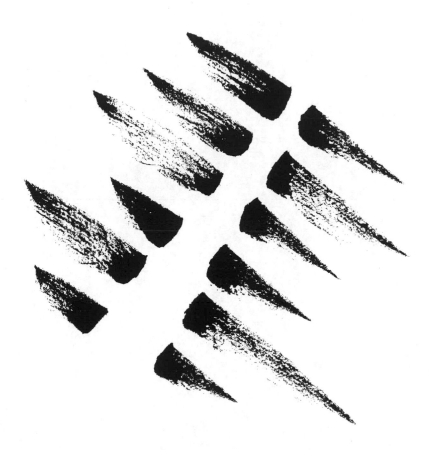

The cheerful parade

To endure

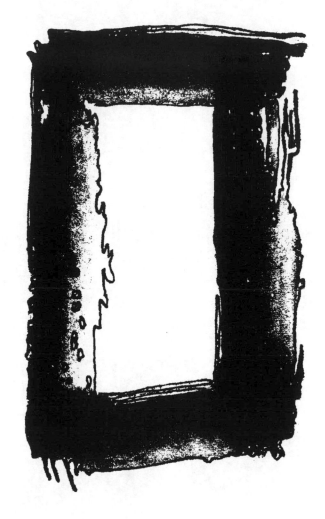

Is to be
filled

New
vistas

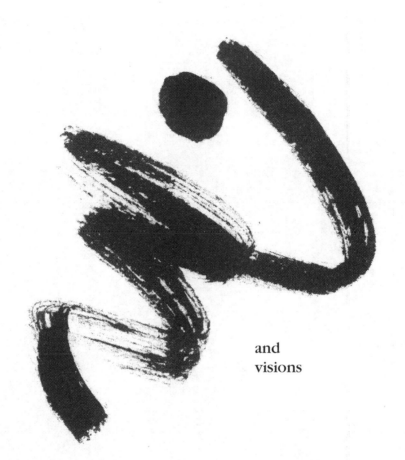

and
visions

The
gentle
way
overcomes
force

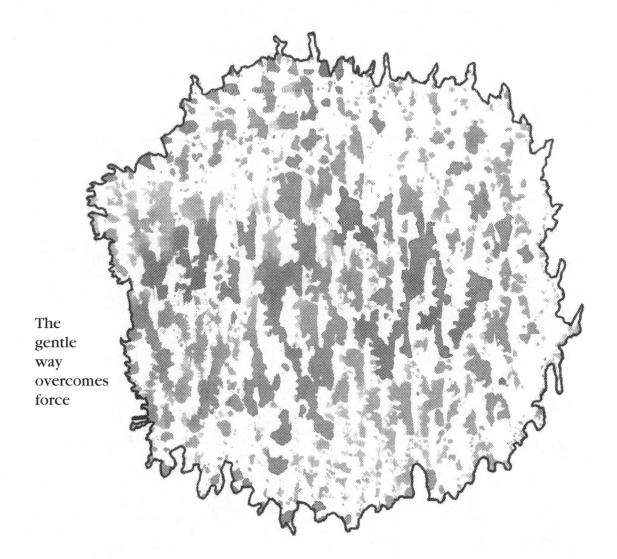

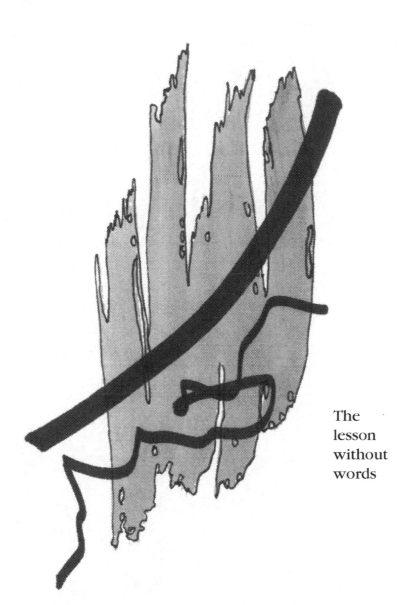

The
lesson
without
words

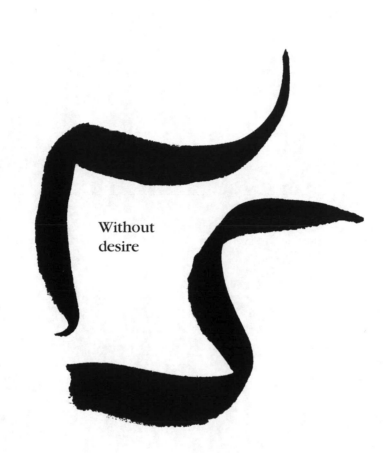

Without
desire

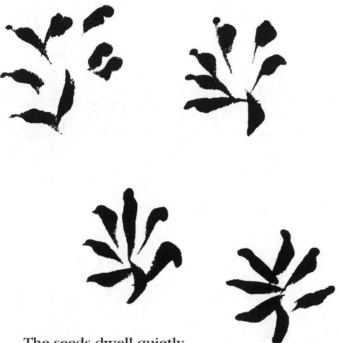

The seeds dwell quietly
within the core of the fruit

nourished

and not upon the petals
of the flower

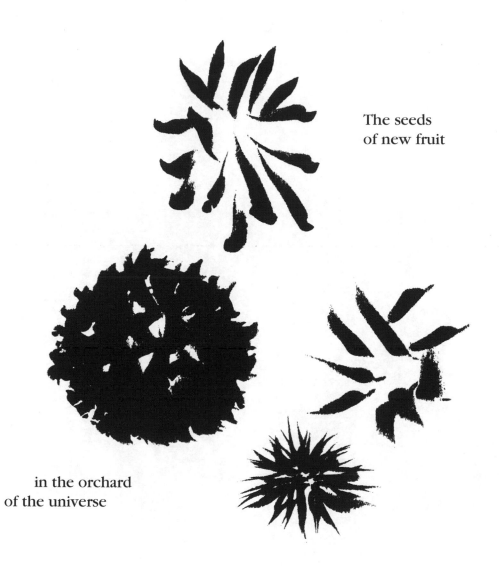

The seeds
of new fruit

in the orchard
of the universe

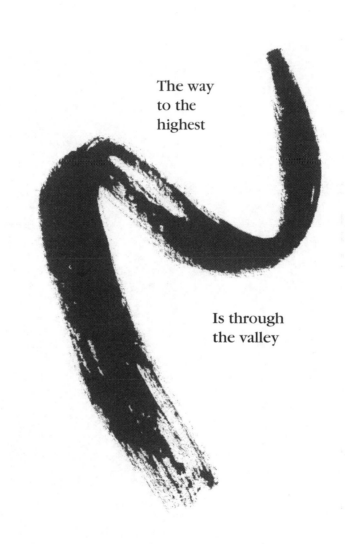

The way
to the
highest

Is through
the valley

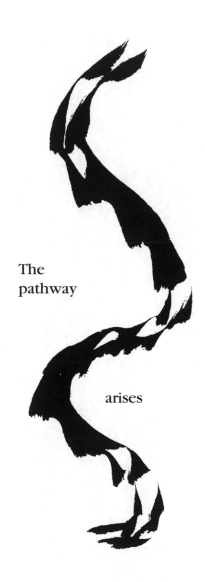

The
pathway

arises

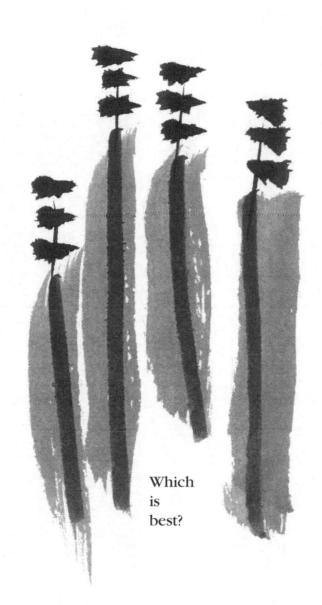

Which
is
best?

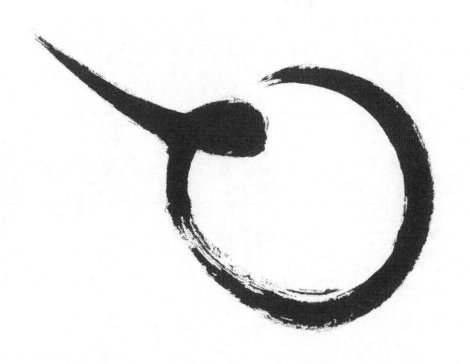

The natural flow overcome activity

Loose
threads

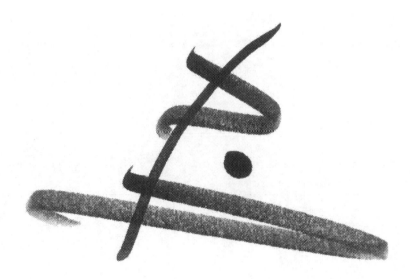

waiting
to be
tied

The lesson
is learned

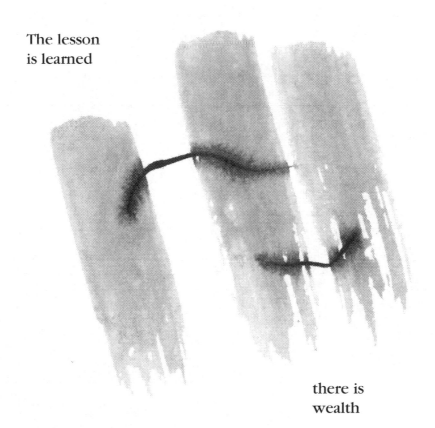

there is
wealth

Only
the
empty

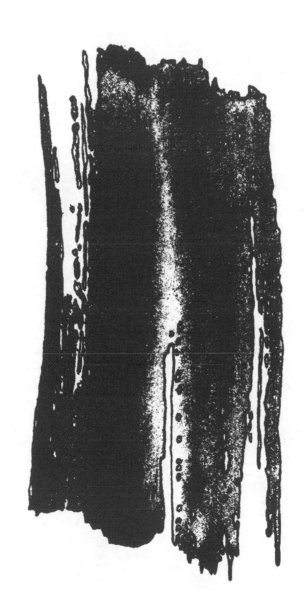

can
be
filled

What
appears
important

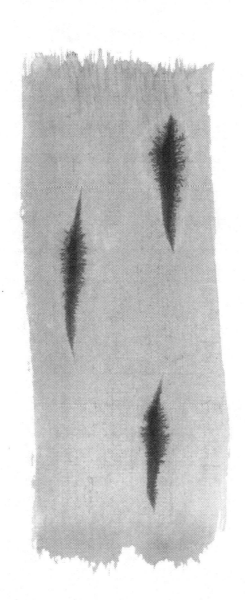

leads
to new
insights

Nourished

Not easily
uprooted

Being

in

tune

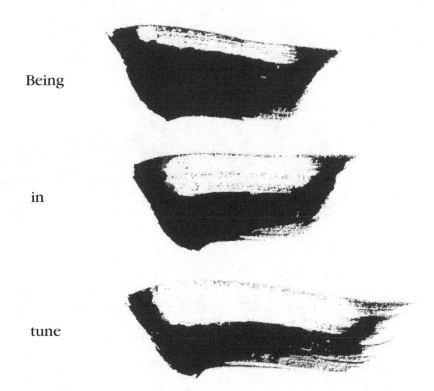

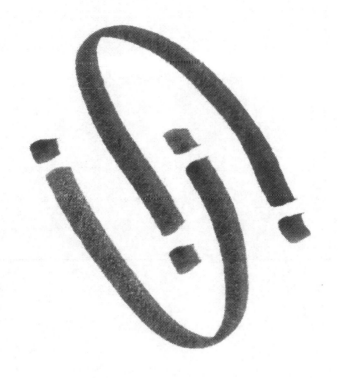

Allow that is there a refuge

and all may be surprised

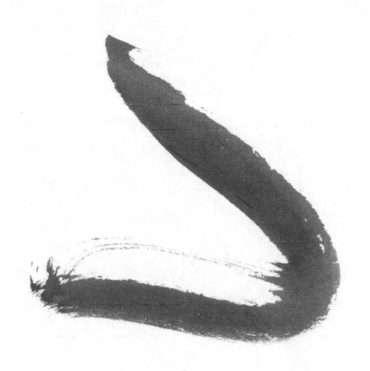

The highest
shall be
honored
upon you

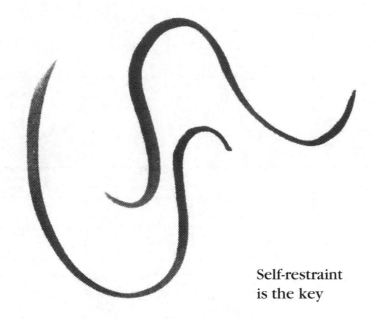

Self-restraint
is the key

The
many
and
the
few
they
are
all
the
same

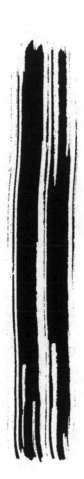

There
will
always
be
an
open
gate

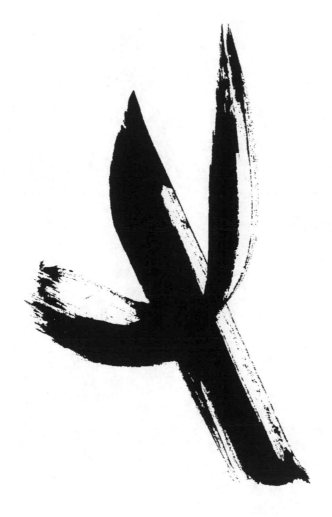

just
around
the
corner

Trace
the
form
of
a
giant
whale

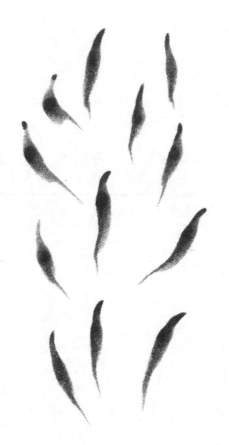

as
you
would
sketch
a
tiny
fish

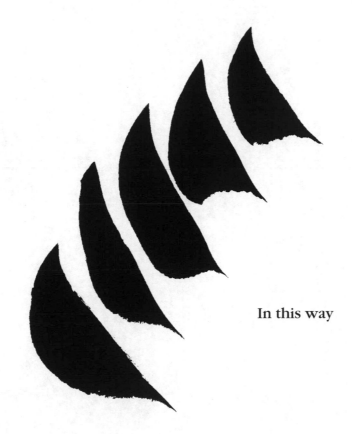

In this way

unlearn

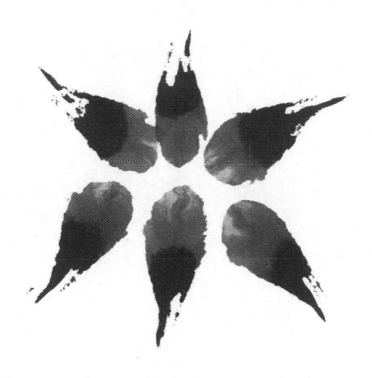

The beauty and harmony of nature

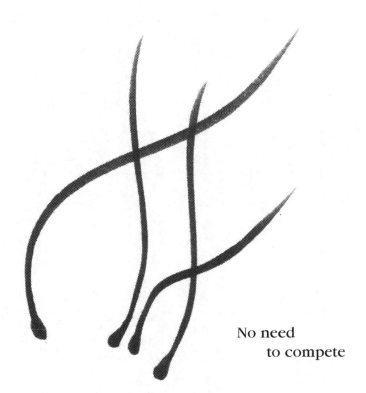

No need
to compete

The
strength
of
reserve

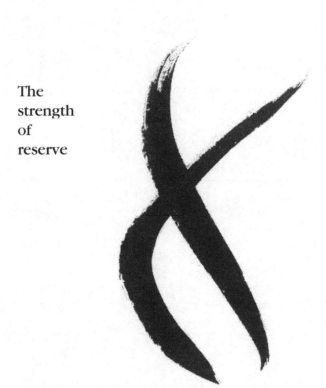

Nature's
science
and
engineering

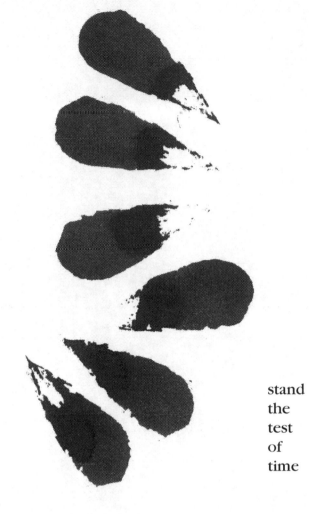

stand
the
test
of
time

The
roads
of
reason
and
factual
knowledge

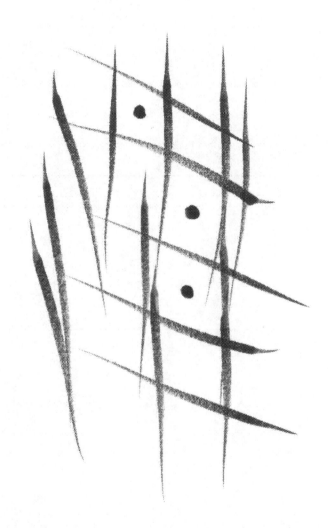

How little
one knows

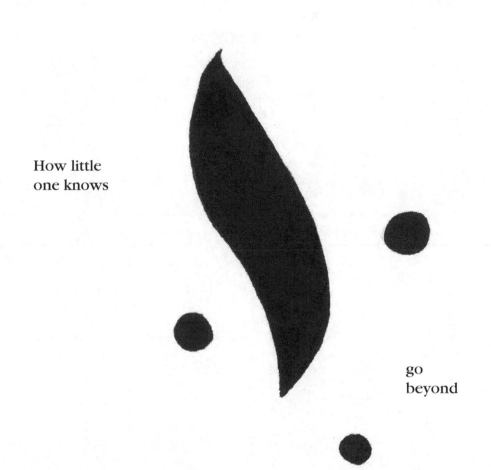

go
beyond

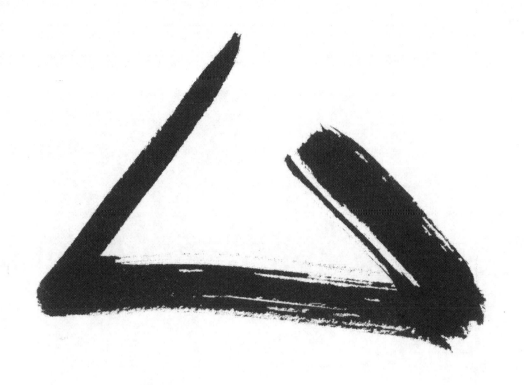

The
peace
which
follows
remains

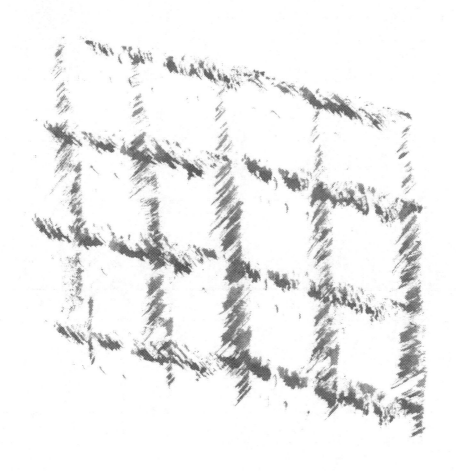

An yet nothing
 open weave is lost

The
center

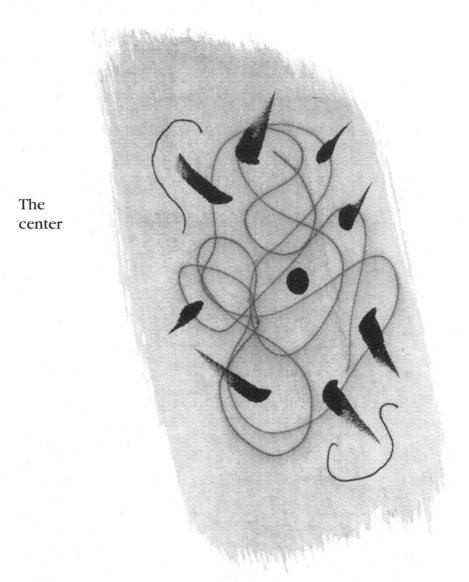

is
strong

Flow
free

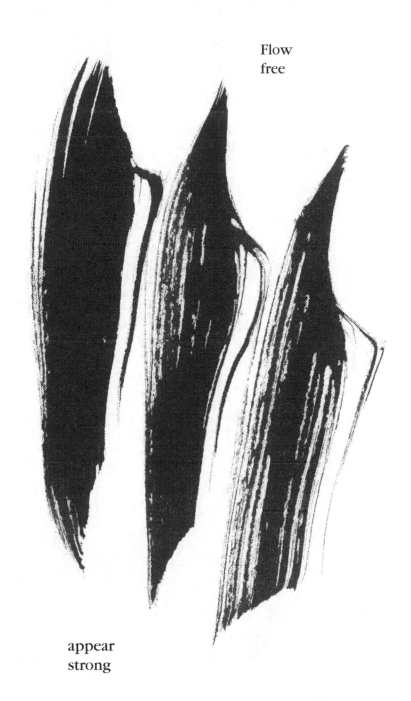

appear
strong

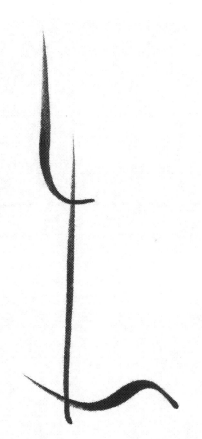

The
parts
fit
without
force

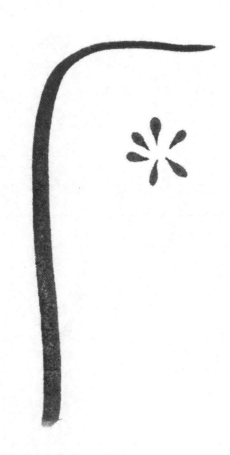

It
remains
gently
at
peace

loses
nothing

Not
led
around
by
the
rules

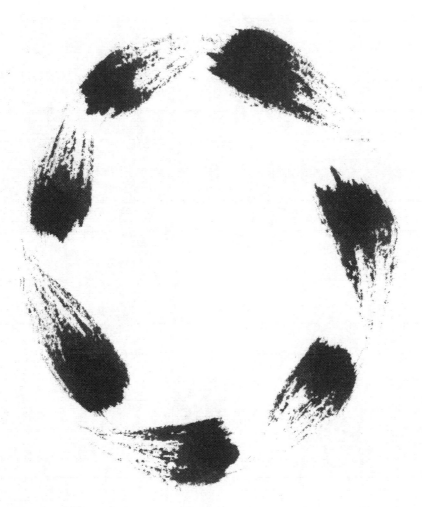

puts
its
blessings
on
all
of
nature